NEW
ERTÉ GRAPHICS
IN FULL COLOR

by
Erté

DOVER PUBLICATIONS, INC.
New York

PREFACE

In 1979 Dover Publications published *Erté Graphics*, containing reproductions of fifty of Erté's earliest graphic works, issued between 1968 and 1977. The present volume shows fifty-six limited-edition graphics printed in 1982, the year in which Erté celebrated his ninetieth birthday. Some are based on very early works in other media; others on works as recent as 1981. All reflect the enormous variety of subject matter to which Erté has applied his unique illustrative gifts.

Erté's treatment of *The Zodiac* (pp. 34–45) is markedly different in spirit and approach from much of the work for which he is best known—fantastic theatrical conceits and highly sophisticated fashion designs. In the original and unusual manner in which he has treated the twelve signs, Erté has shown that, at an age when he might be excused for relying on formulae, he is not content to repeat any subject, but continues to make exacting demands on his imagination and technique. *The Seven Deadly Sins* (pp. 27–33), reflecting extensive worldly experience, is the work of an artist who, while accepting sin as an unavoidable human characteristic, never descends to cynicism. The originals were painted between 1979 and

1981. Both suites of prints were published by Tristar Publishing, Ltd.

Erté's newest publisher, Impress Graphics, has issued a portfolio of five figures, *At the Theatre* (pp. 14–18 left), demonstrating the artist's seemingly endless inspiration by and for the theater, for which he has worked more than seventy years.

"Ebony and White" (p. 18 right), published by Sevenarts Ltd., London, is based on an original work of 1981. It is a contemporary image, inspired by a design of 1938, "Symphony in Black," and is here shown next to the 1982 interpretation of that work.

This volume also includes the last Erté serigraphs to be published by Circle Fine Art: "The Nile" (p. 19); "The Golden Pearls" (back cover); and a new, embellished and technically improved edition of *The Four Emotions* (p. 46).

The remaining prints (including the front cover), of various subjects, are among Erté's personal favorites. They were published by Chalk & Vermilion Fine Arts, Ltd., some on black or velvety gray paper, using very sophisticated techniques.

SALOME ESTORICK

Copyright © 1984 by Sevenarts Limited.
© 1984 by Dover Publications, Inc.
All rights reserved under Pan American and International Copyright Conventions.

Published in Canada by General Publishing Company, Ltd., 30 Lesmill Road, Don Mills, Toronto, Ontario.
Published in the United Kingdom by Constable and Company, Ltd., 10 Orange Street, London WC2H 7EG.

New Erté Graphics in Full Color is a new work, first published by Dover Publications, Inc., in 1984.

Manufactured in the United States of America
Dover Publications, Inc., 31 East 2nd Street, Mineola, N.Y. 11501

Library of Congress Cataloging in Publication Data

Erté.
 New Erté graphics in full color.

 I. Erté. I. Title.
NE2238.5.E77A4 1984 760'.092'4 83-20658
ISBN 0-486-24645-0

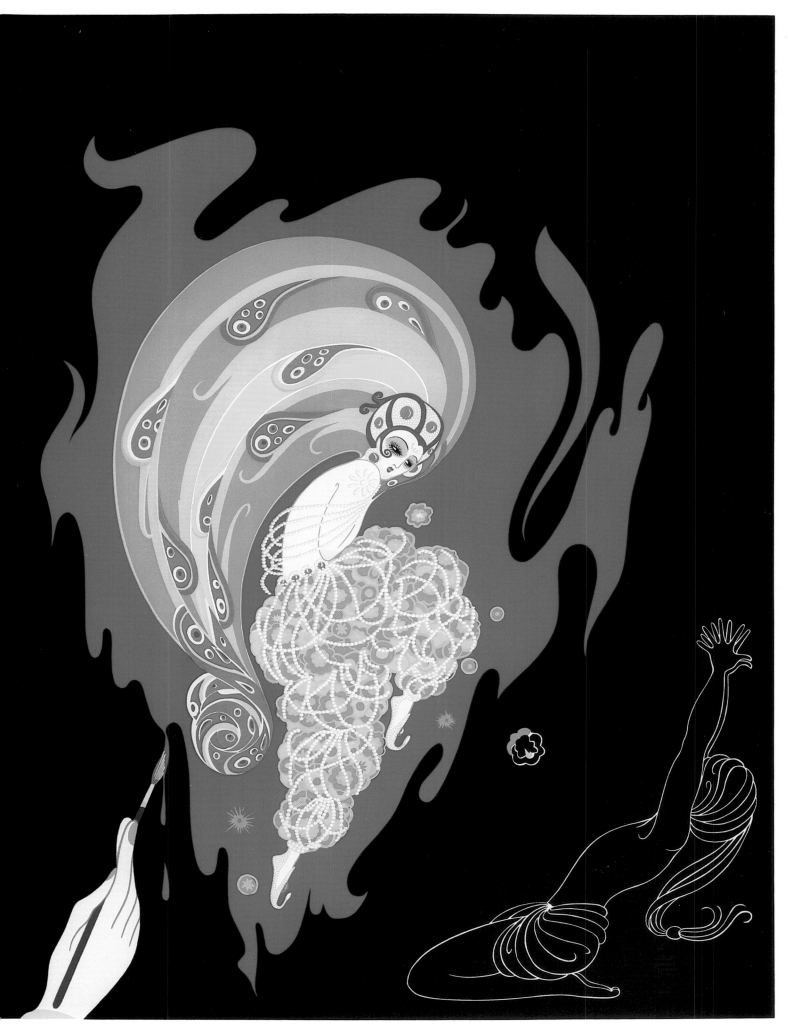

Oriental Tale

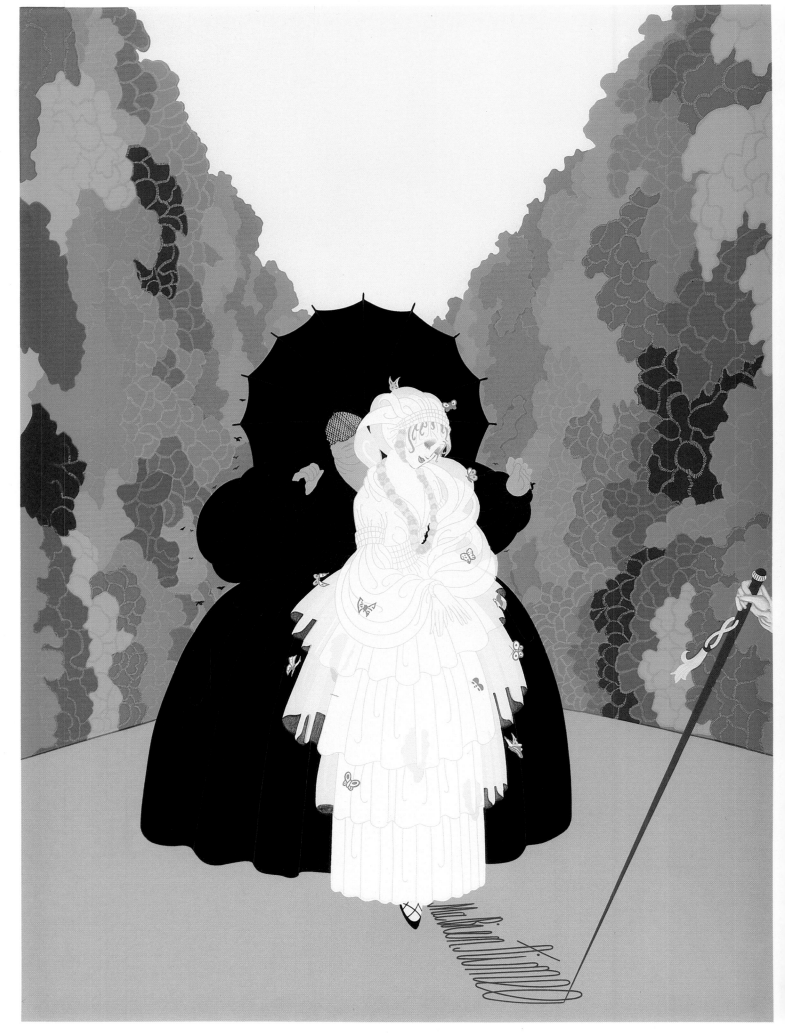

Debutante

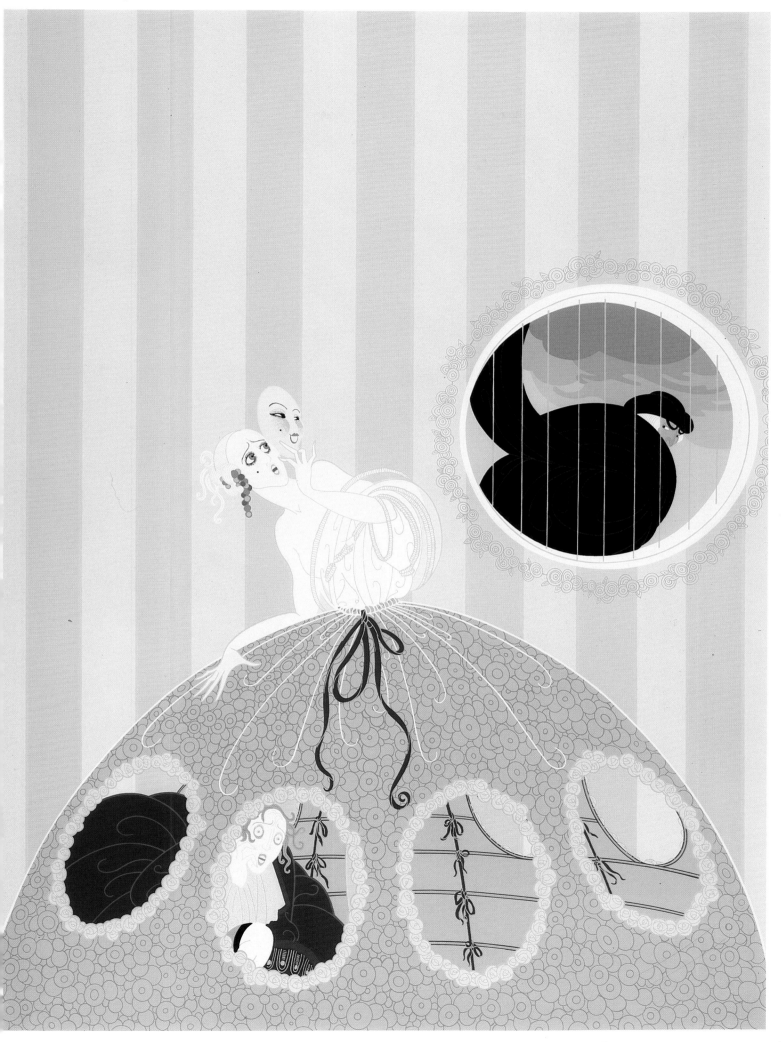

Deception

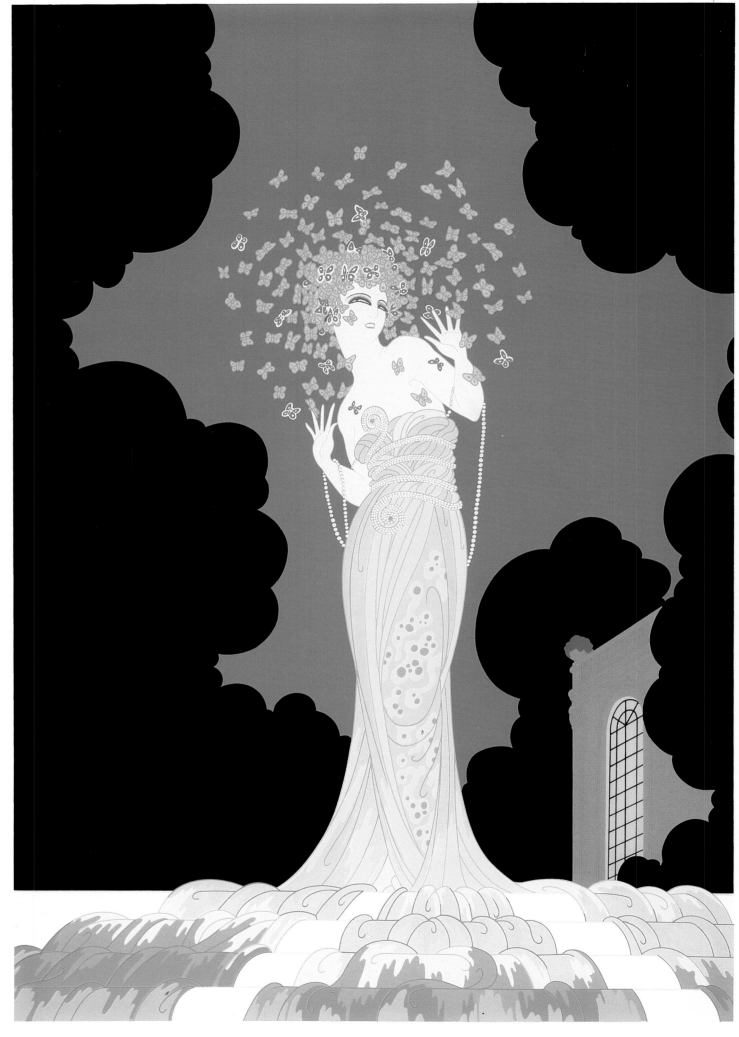

Fantasia

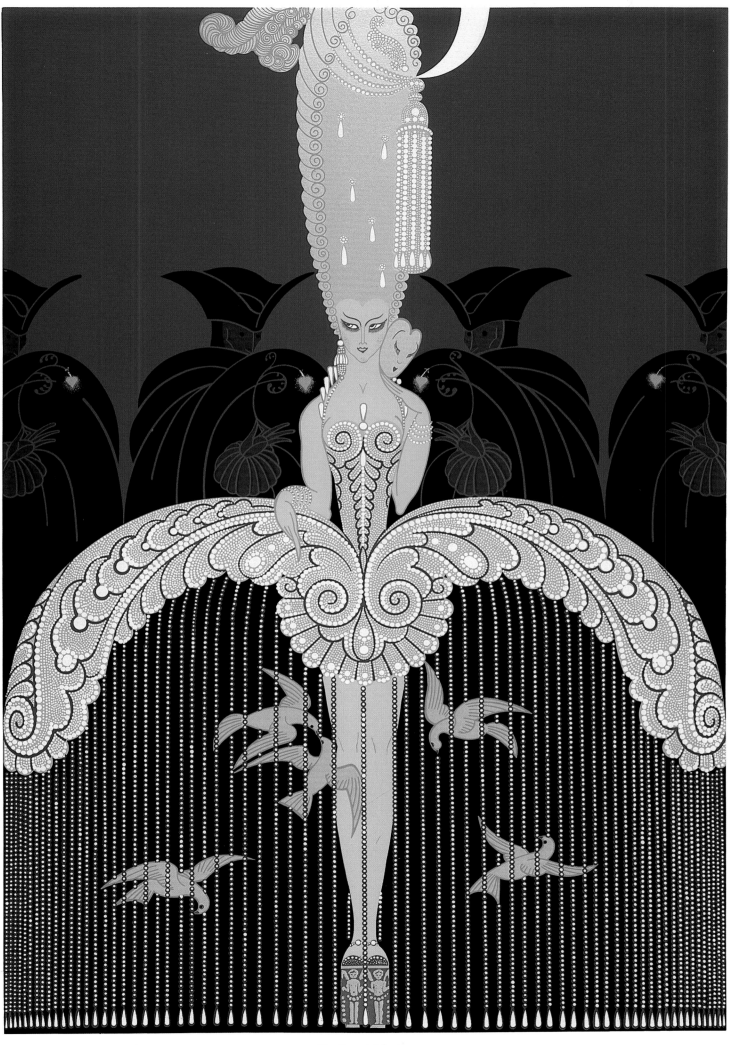

Her Secret Admirers

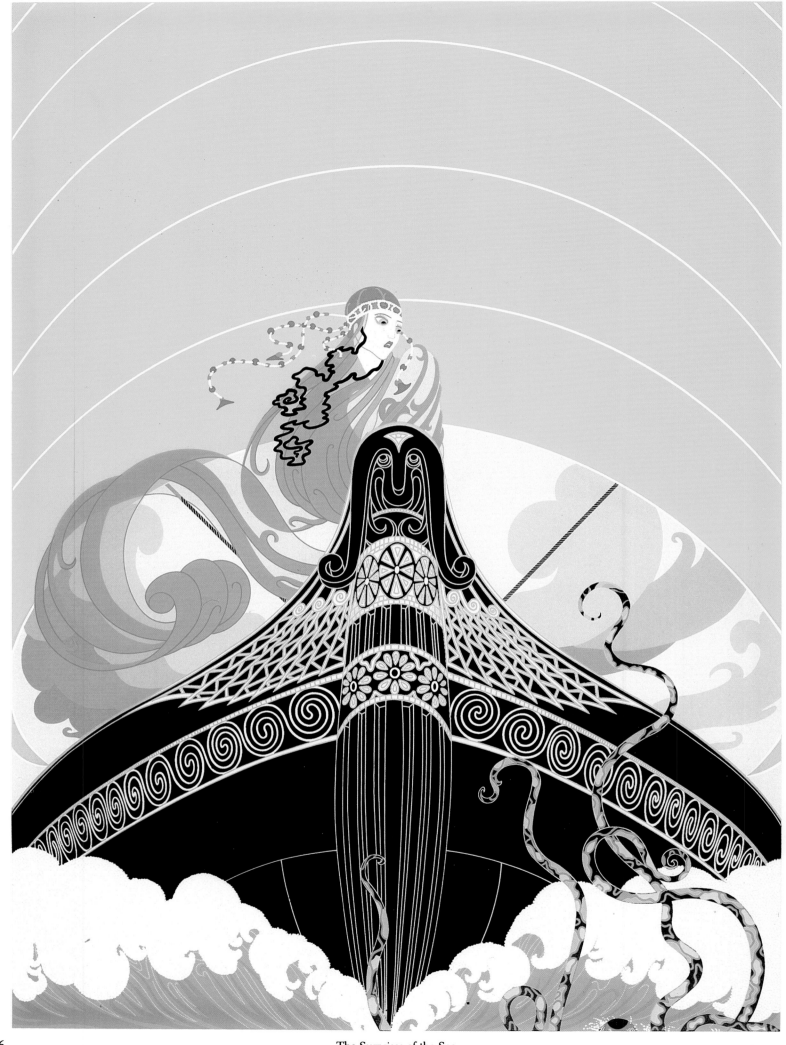

The Surprises of the Sea

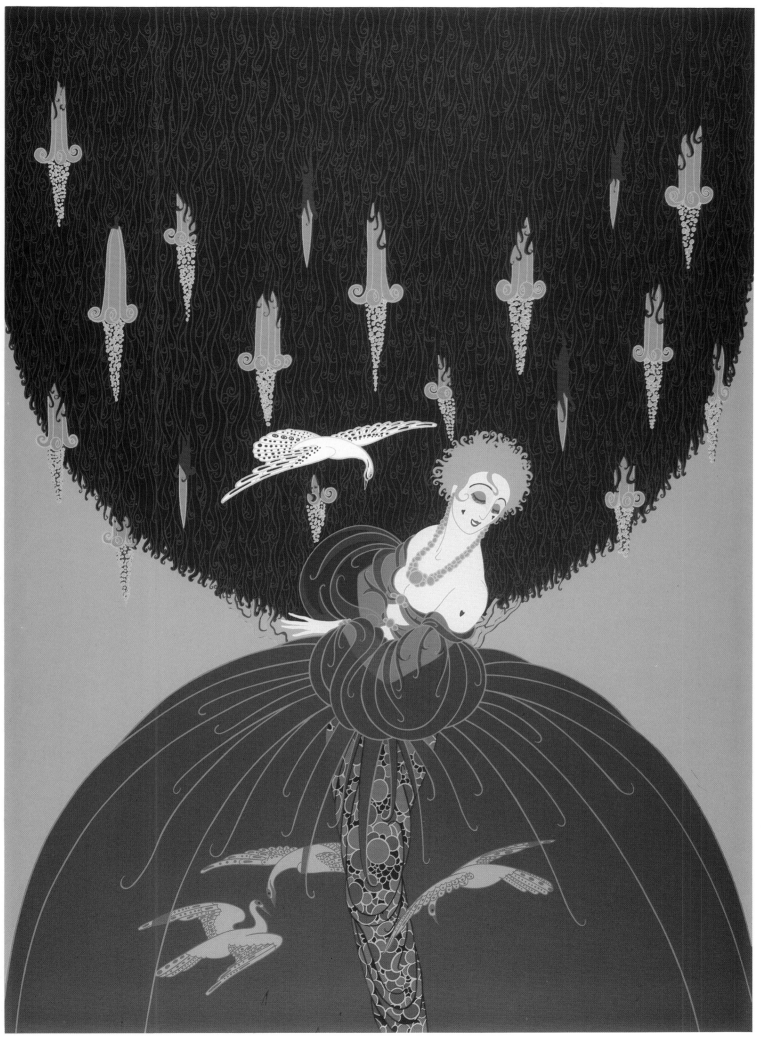

Freedom and Captivity

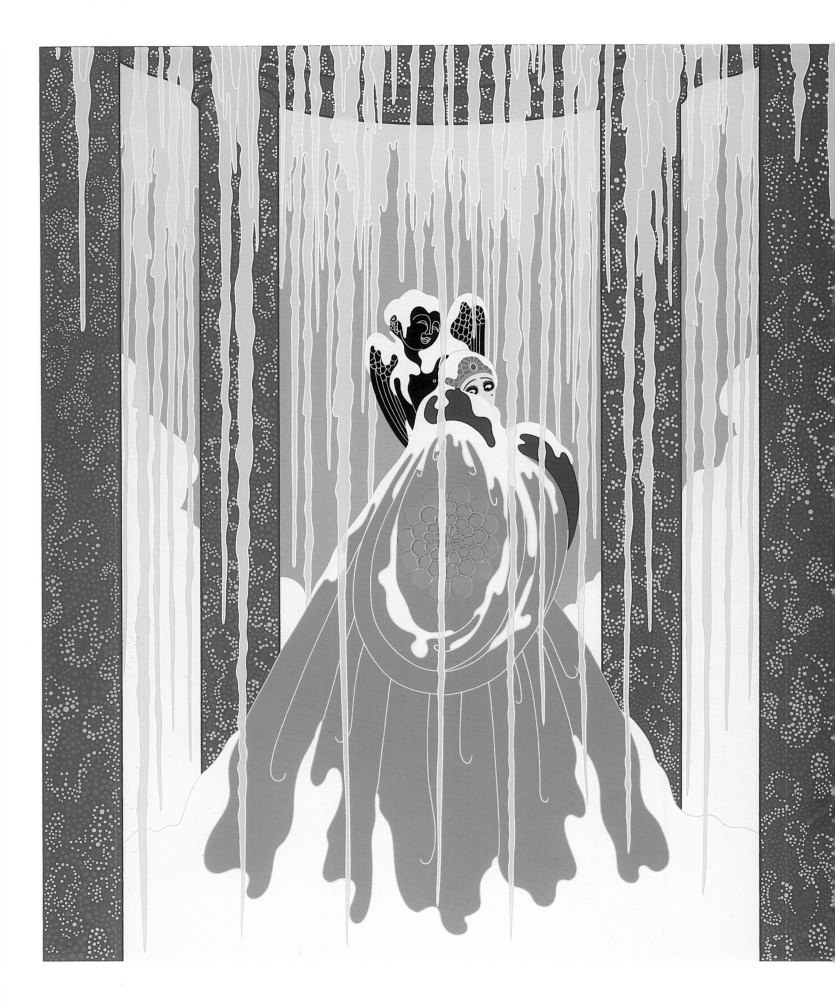

Love's Captive

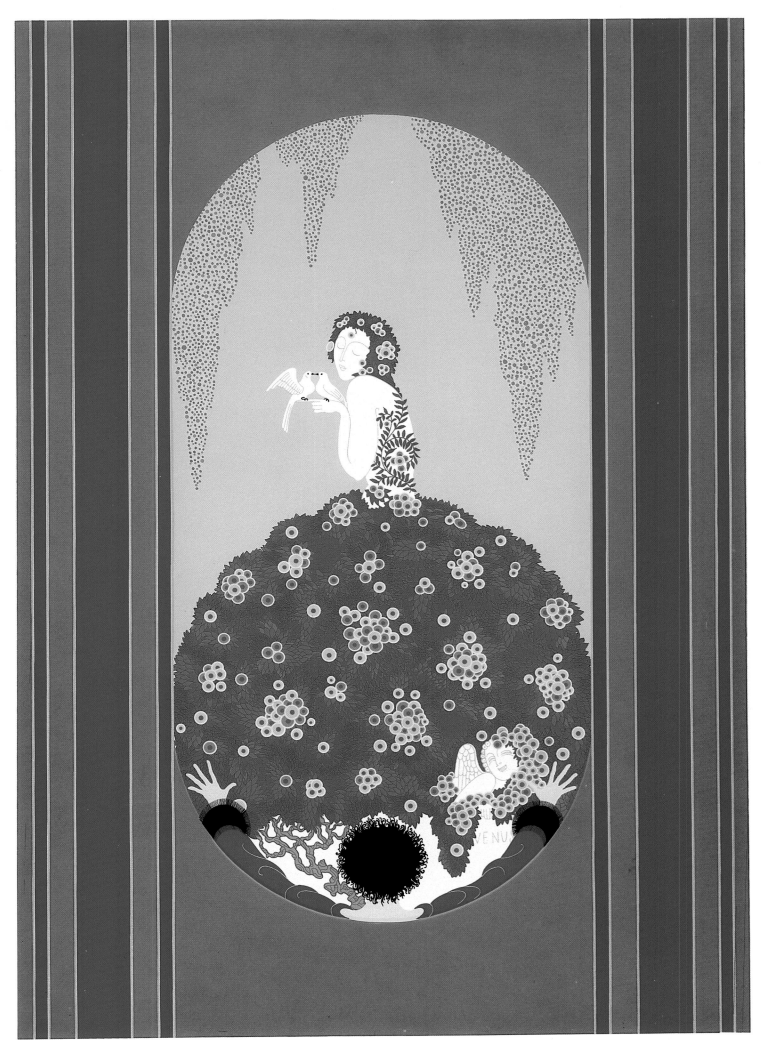

Venus

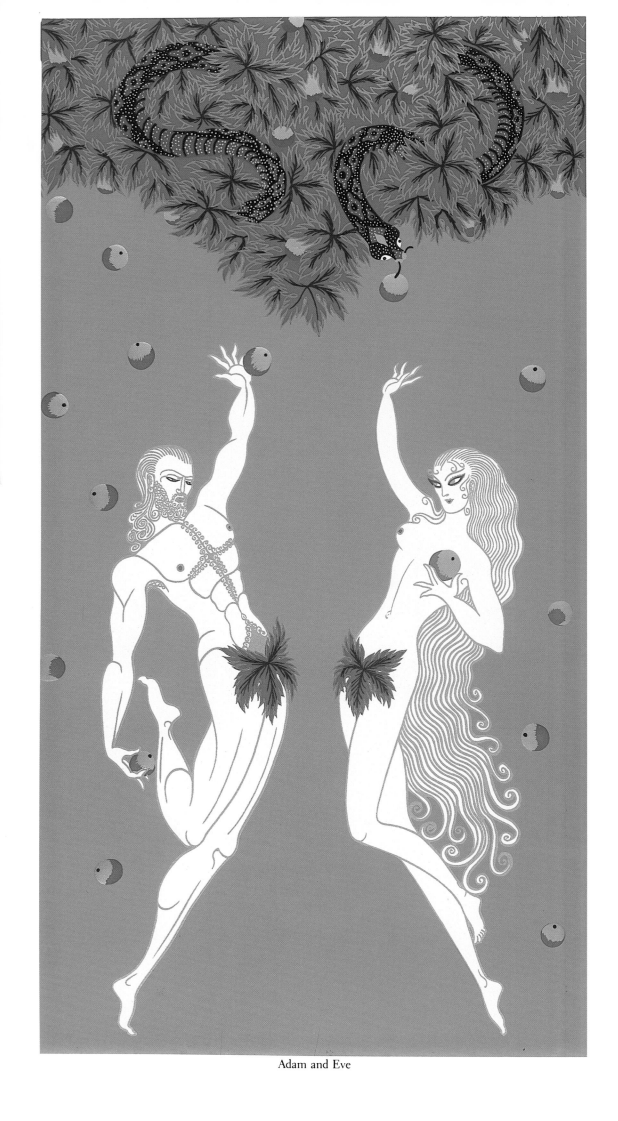

Adam and Eve

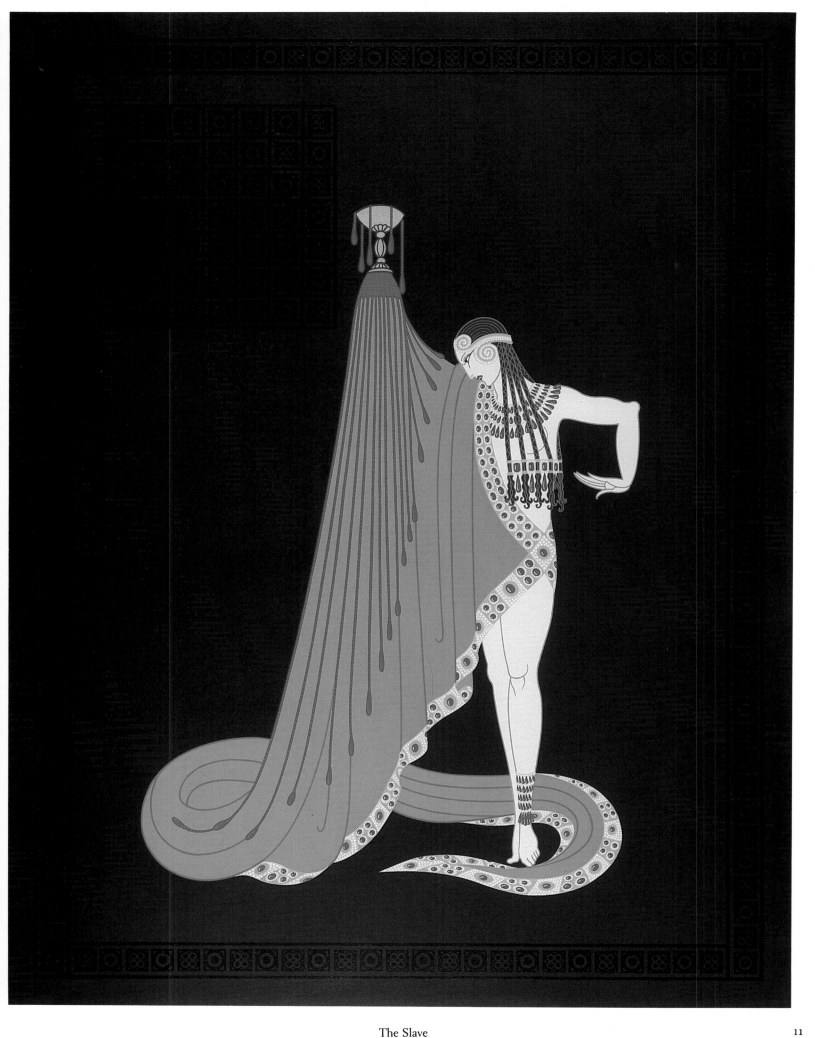

The Slave

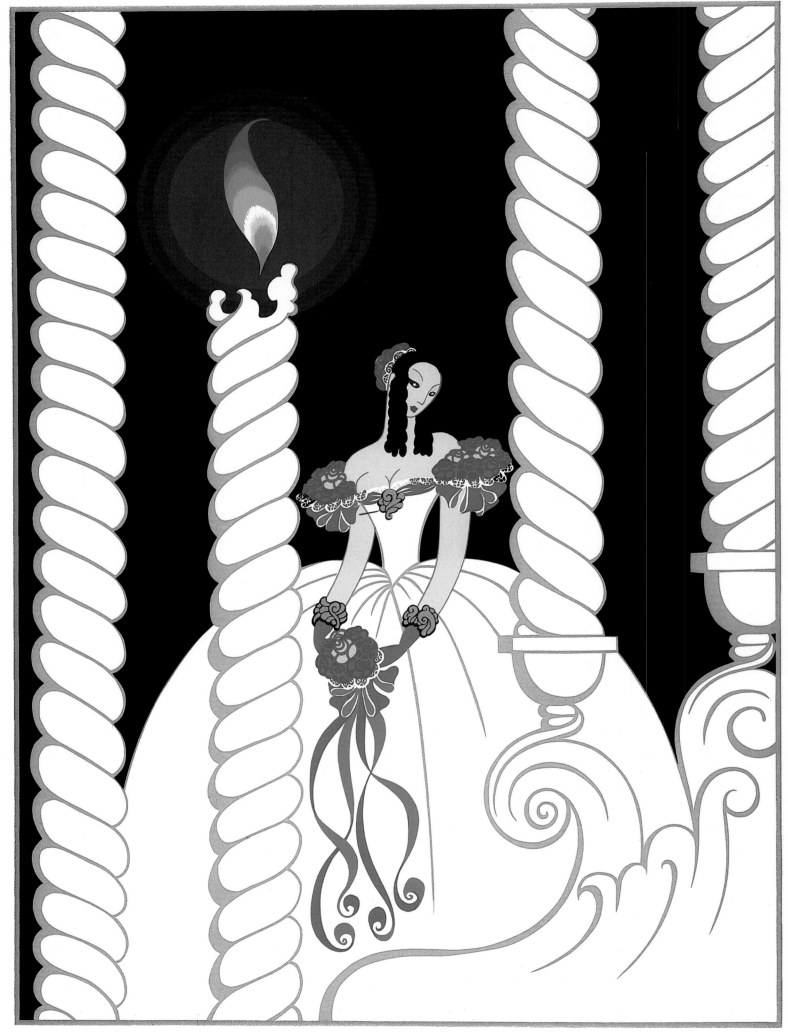

La Traviata

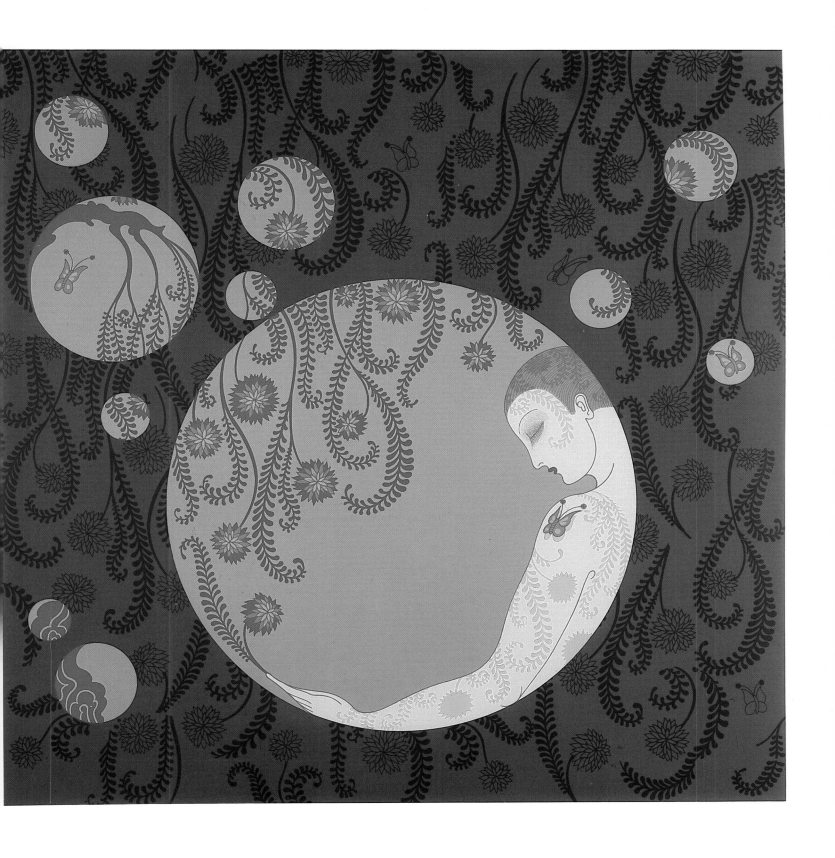

Spring Shadows

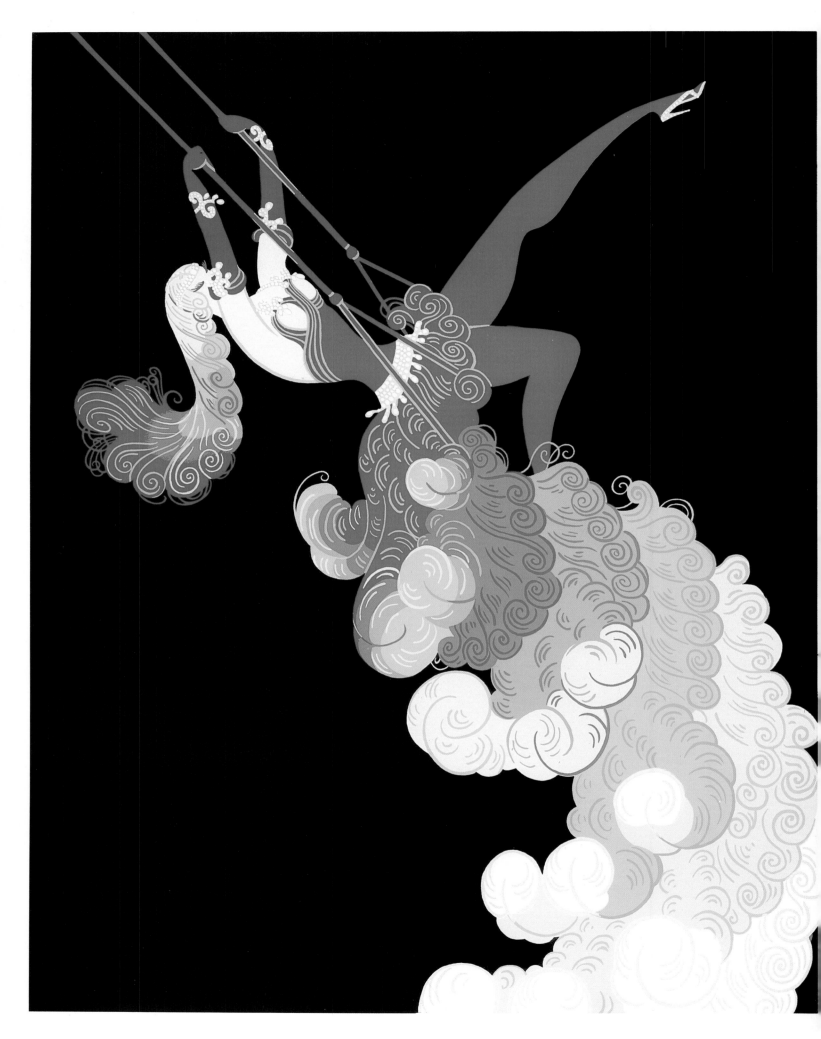

At the Theatre: Trapeze

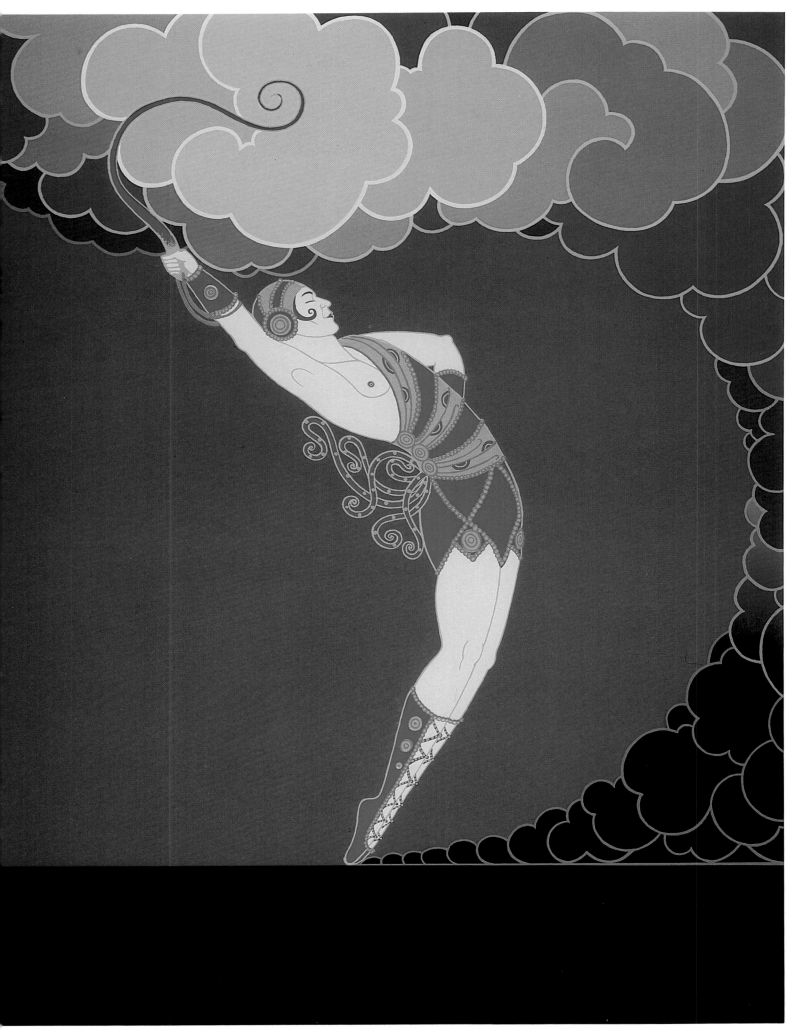

At the Theatre: The Dancer

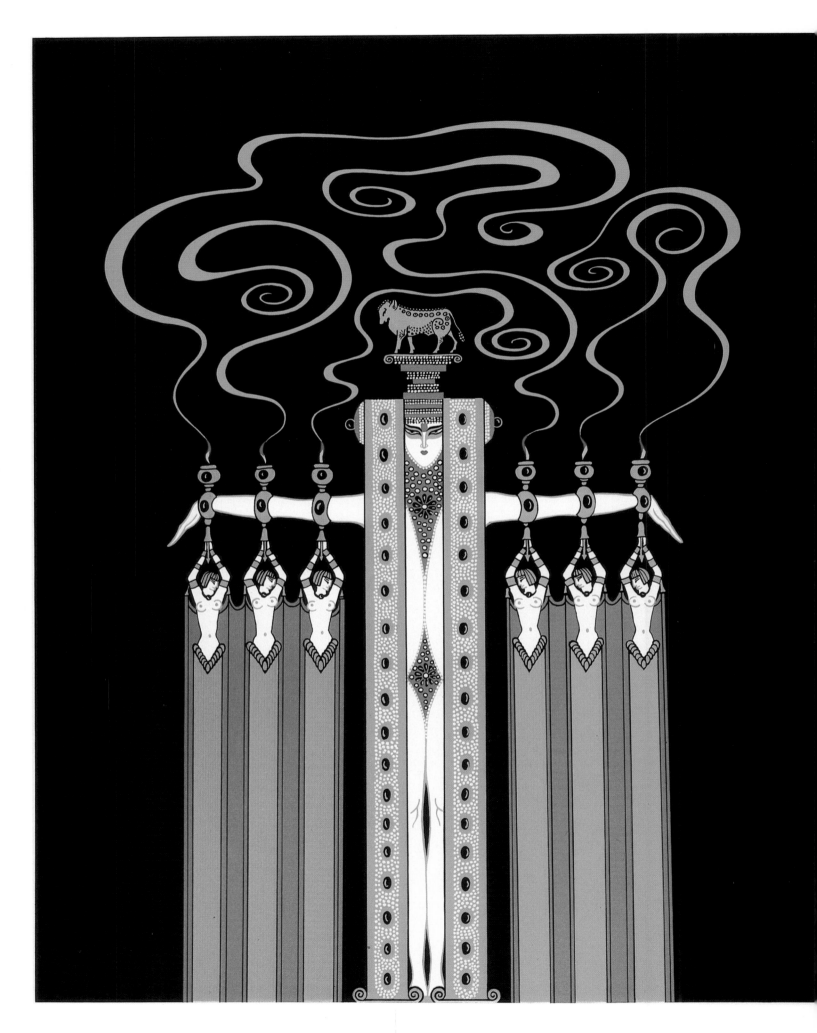

At the Theatre: Golden Calf

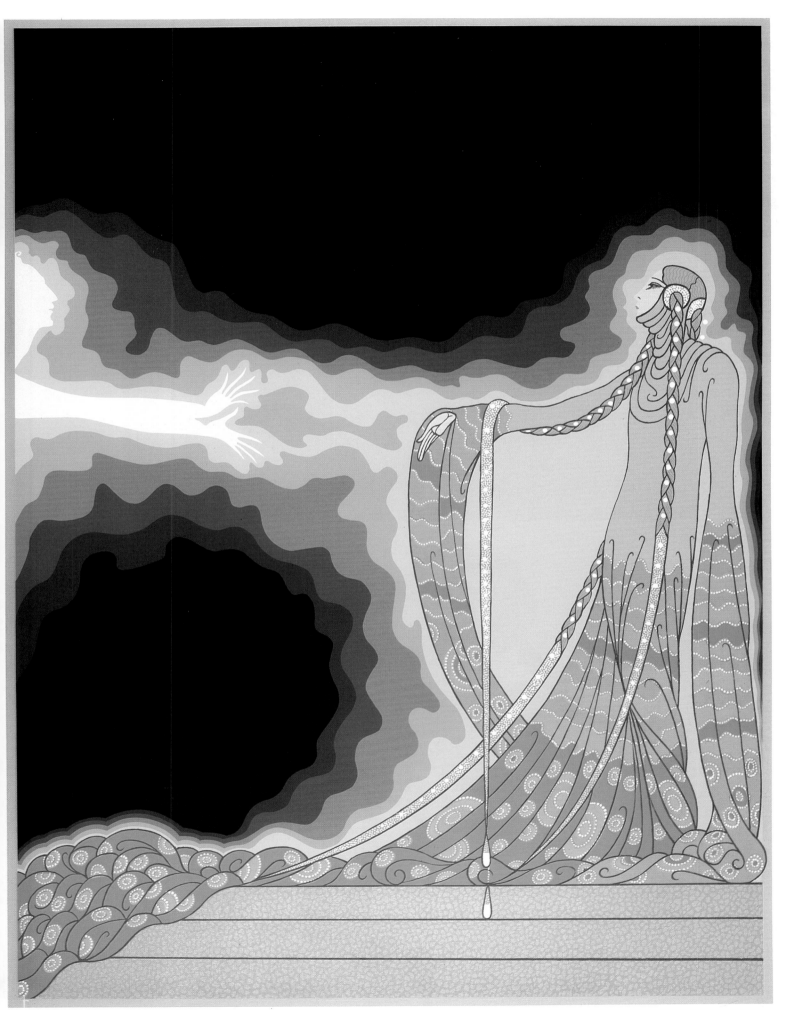

At the Theatre: Mélisande

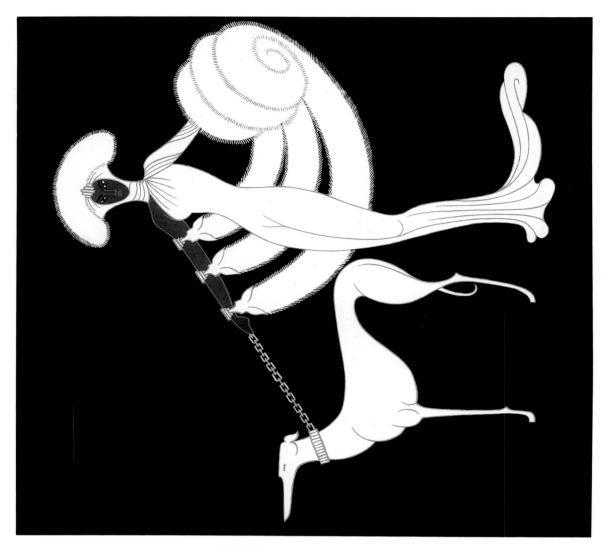

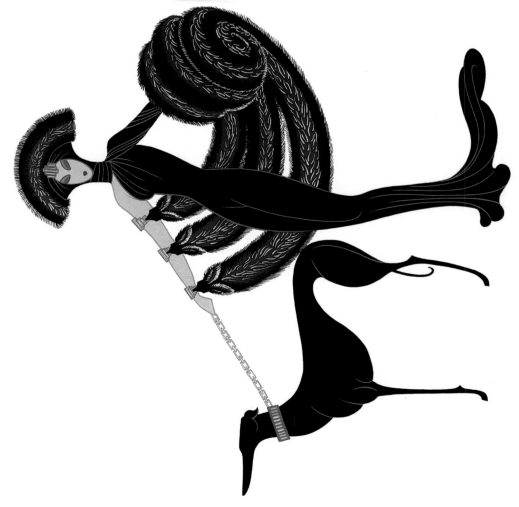

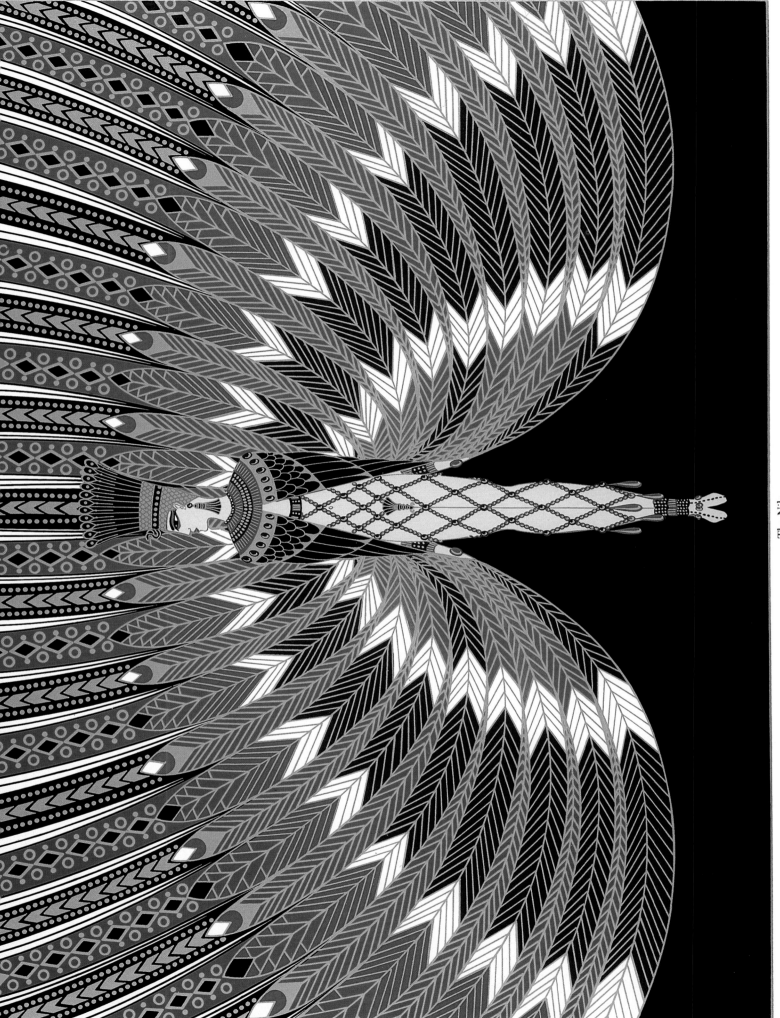

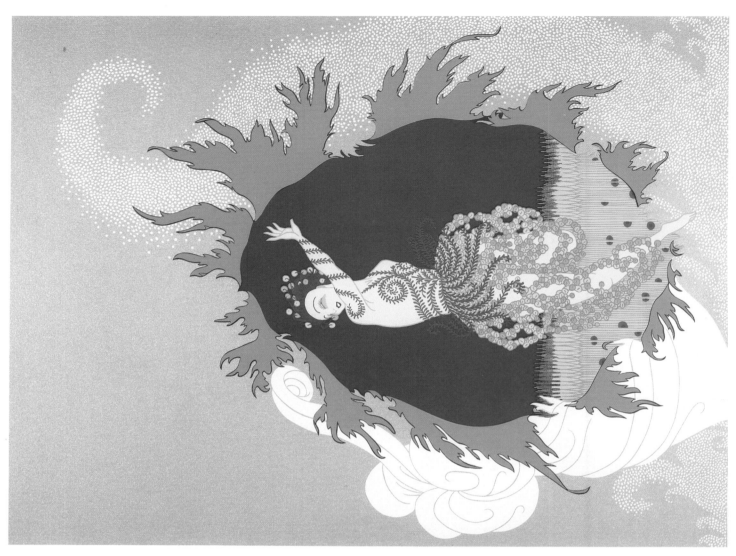

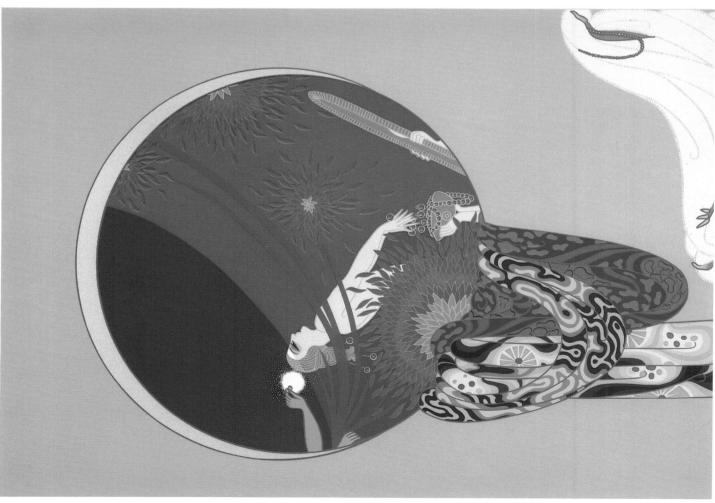

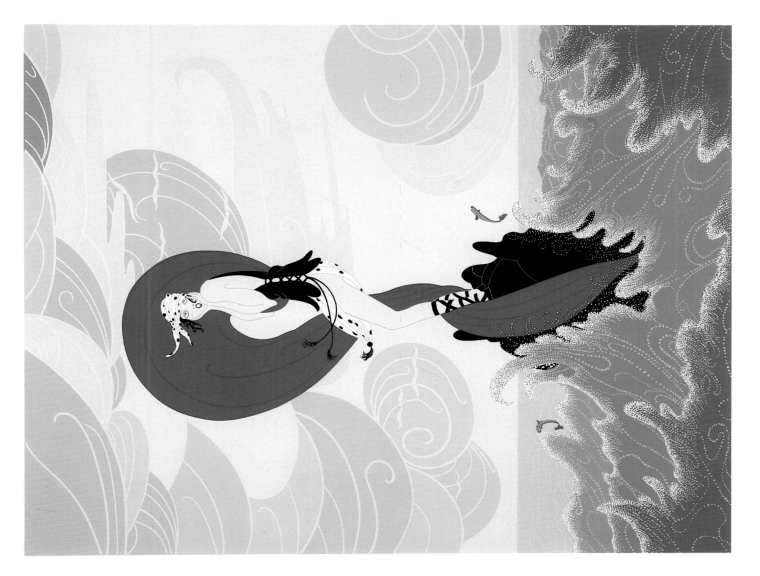

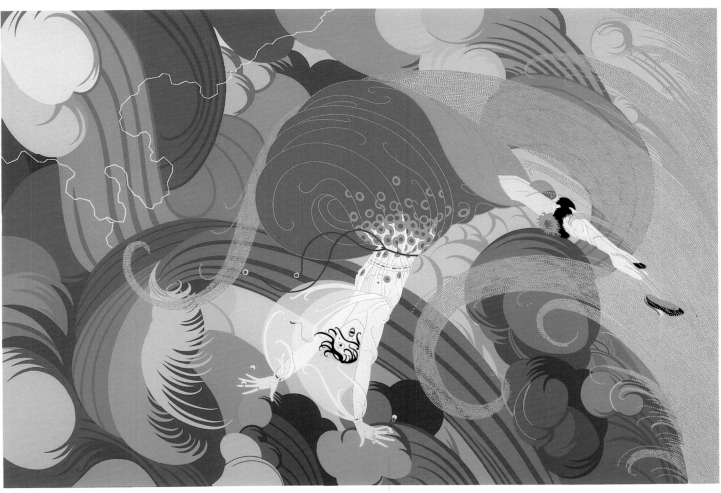

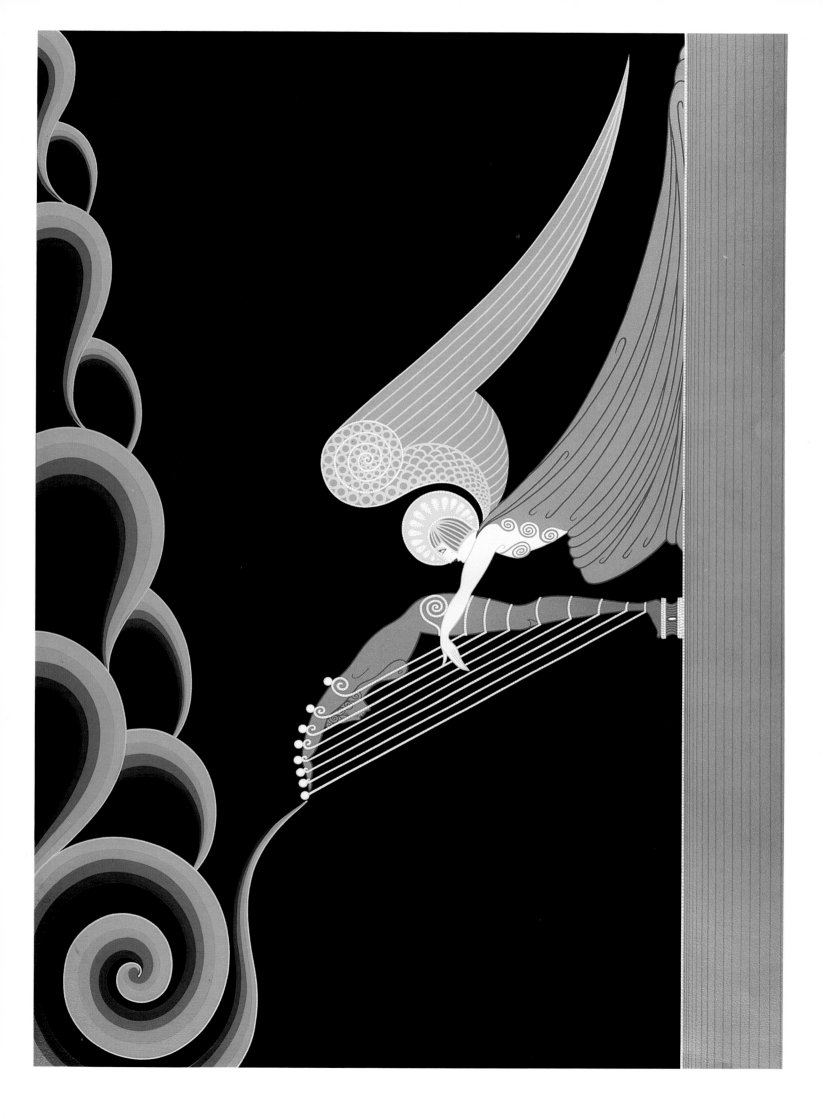

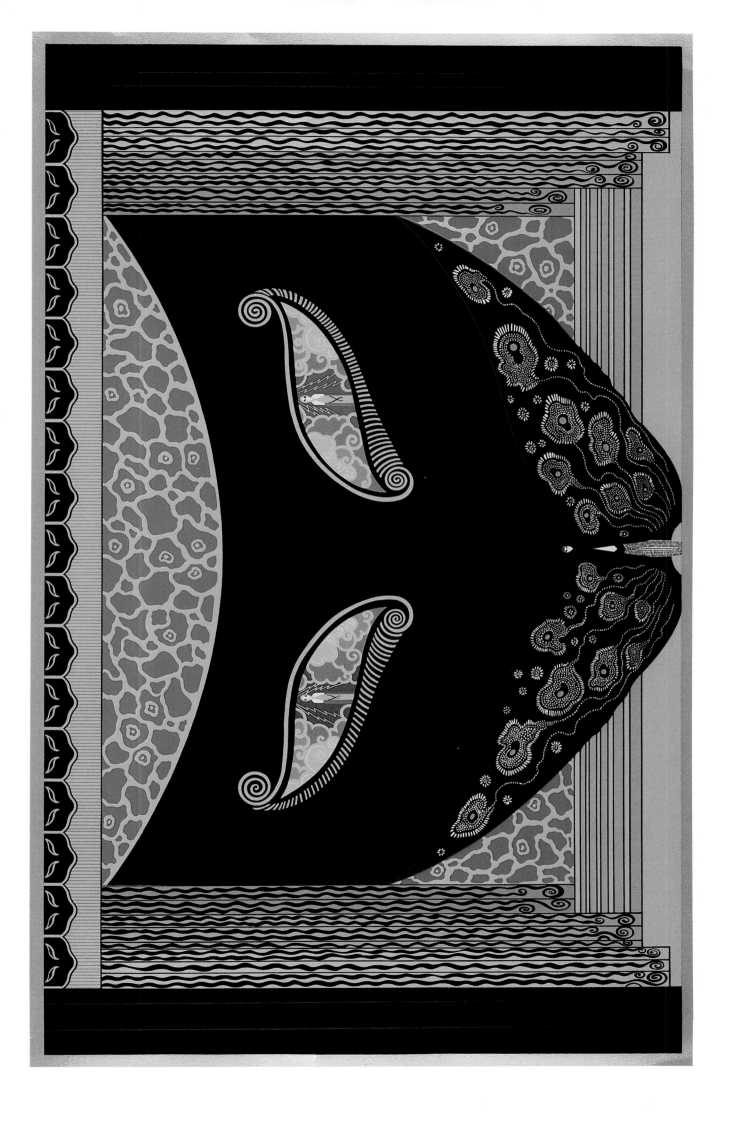

Eyes of Jealousy

23

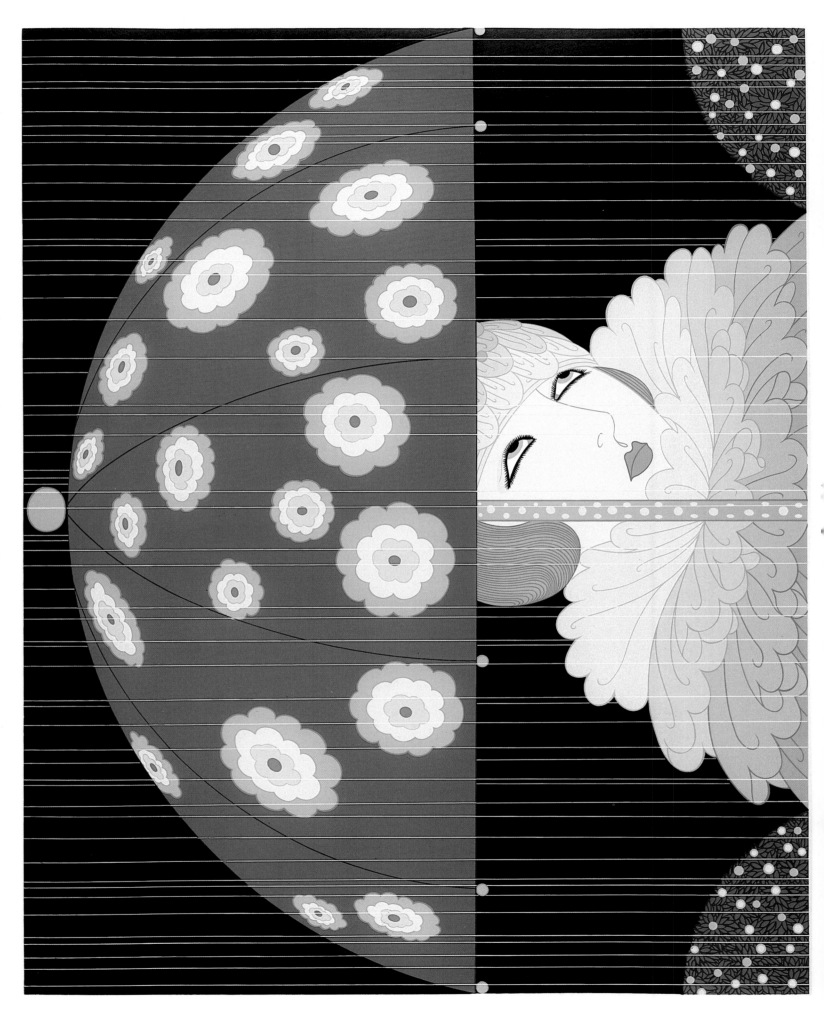

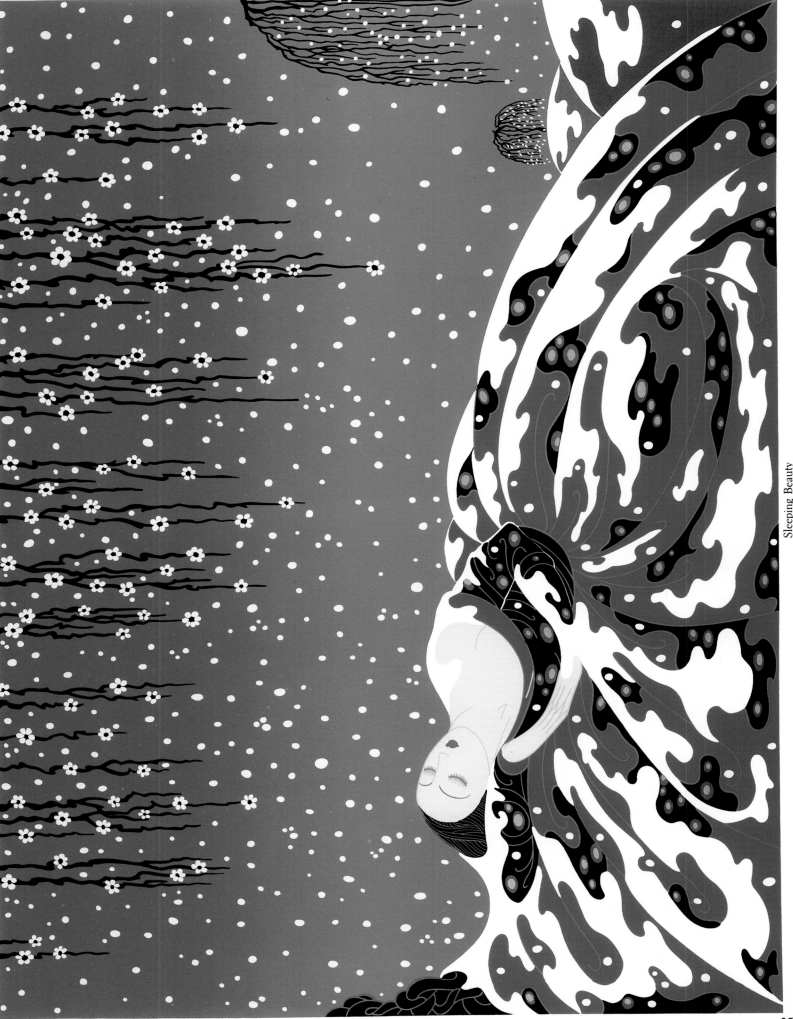

Sleeping Beauty

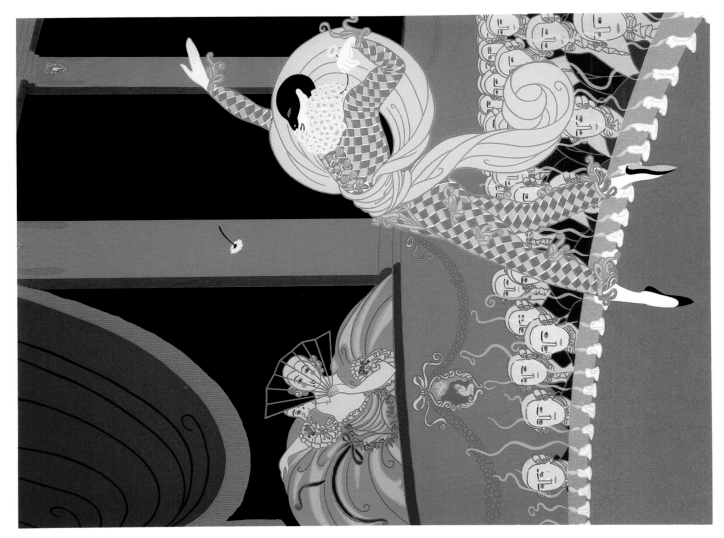

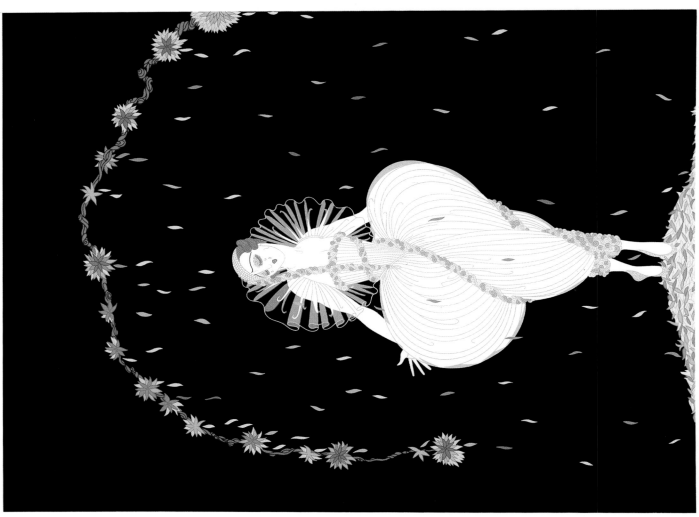

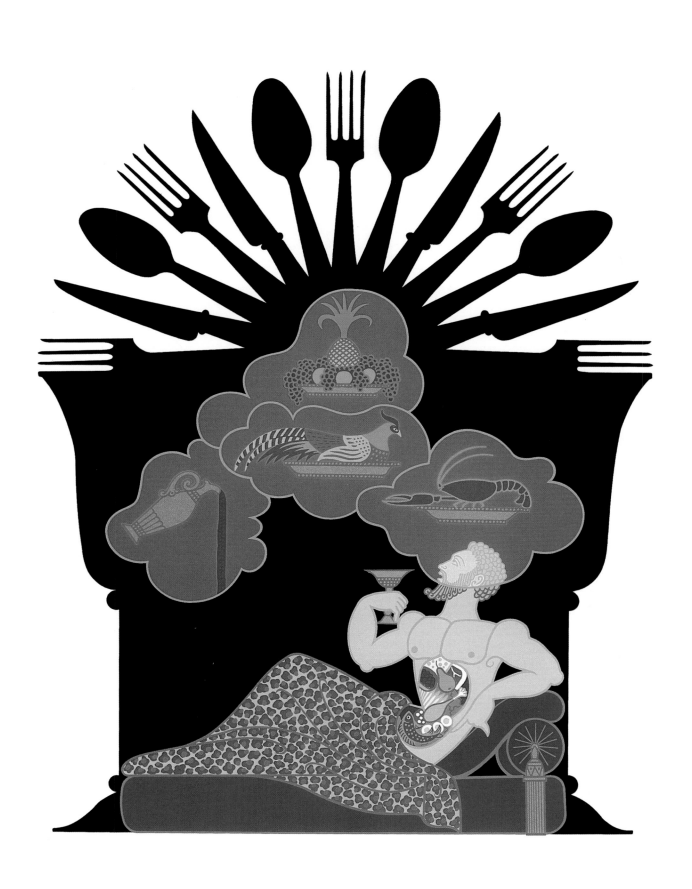

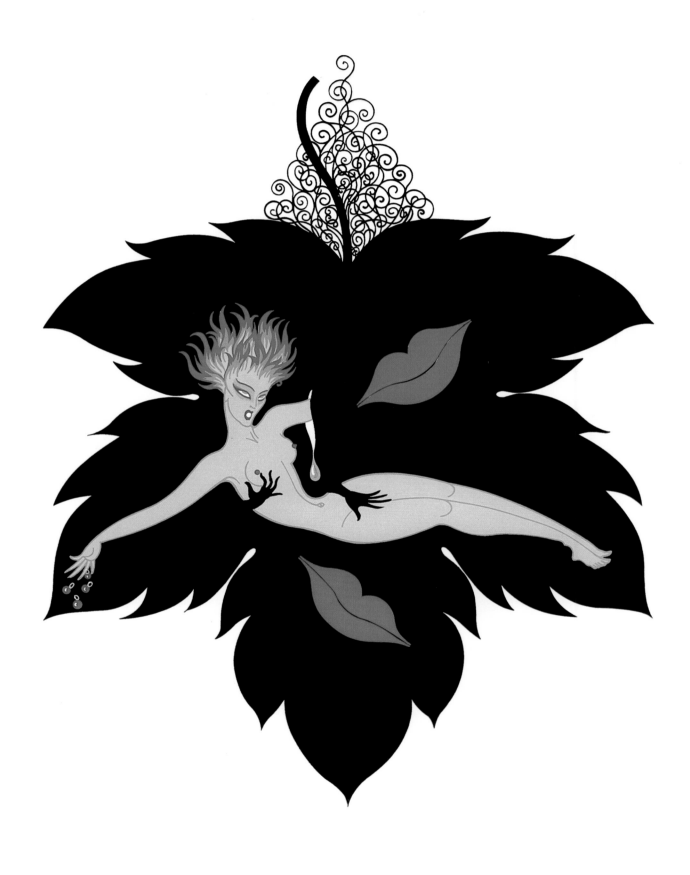

The Seven Deadly Sins: Lust

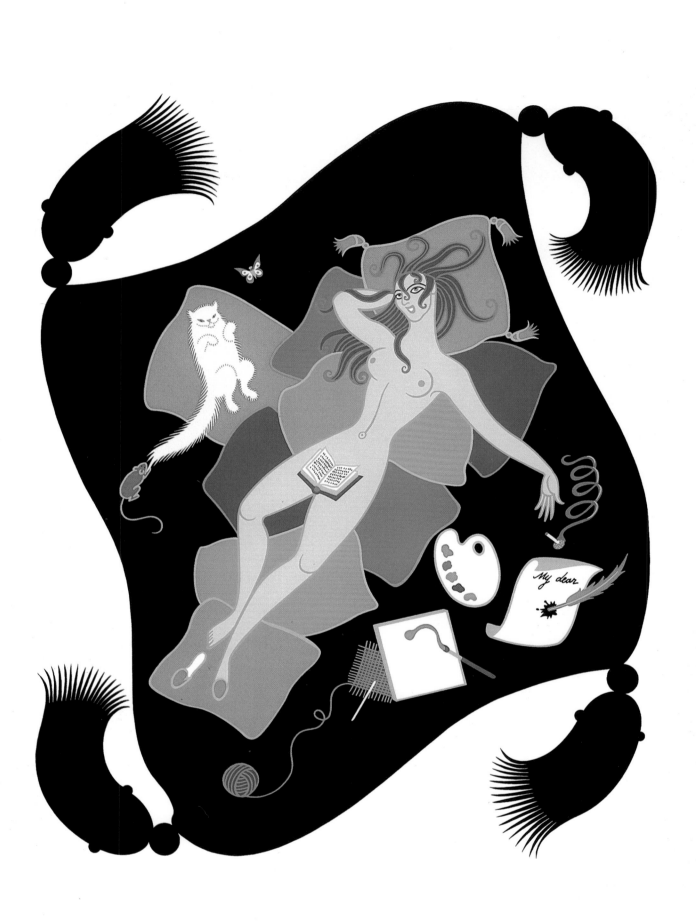

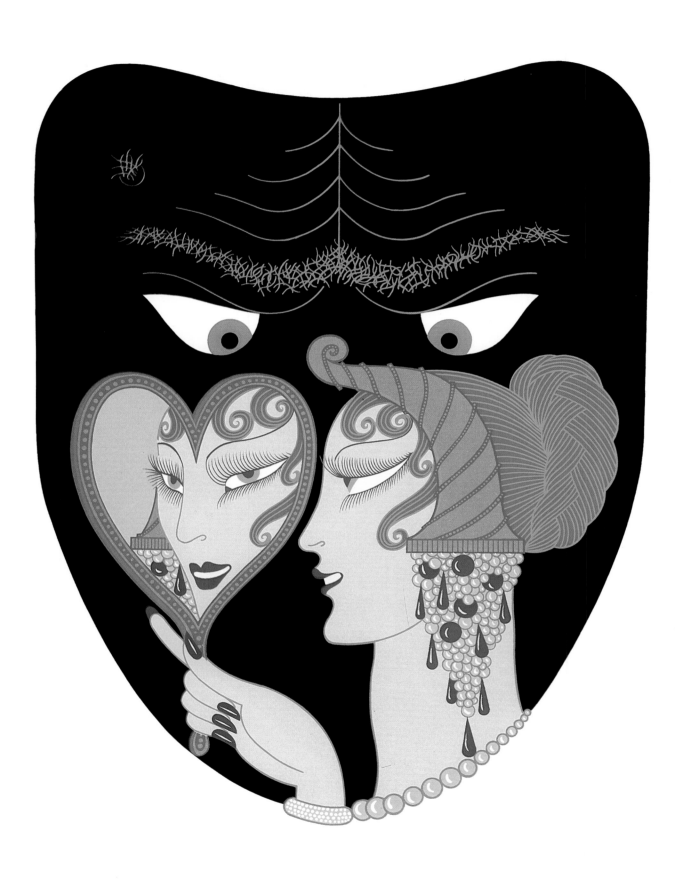

The Seven Deadly Sins: Envy

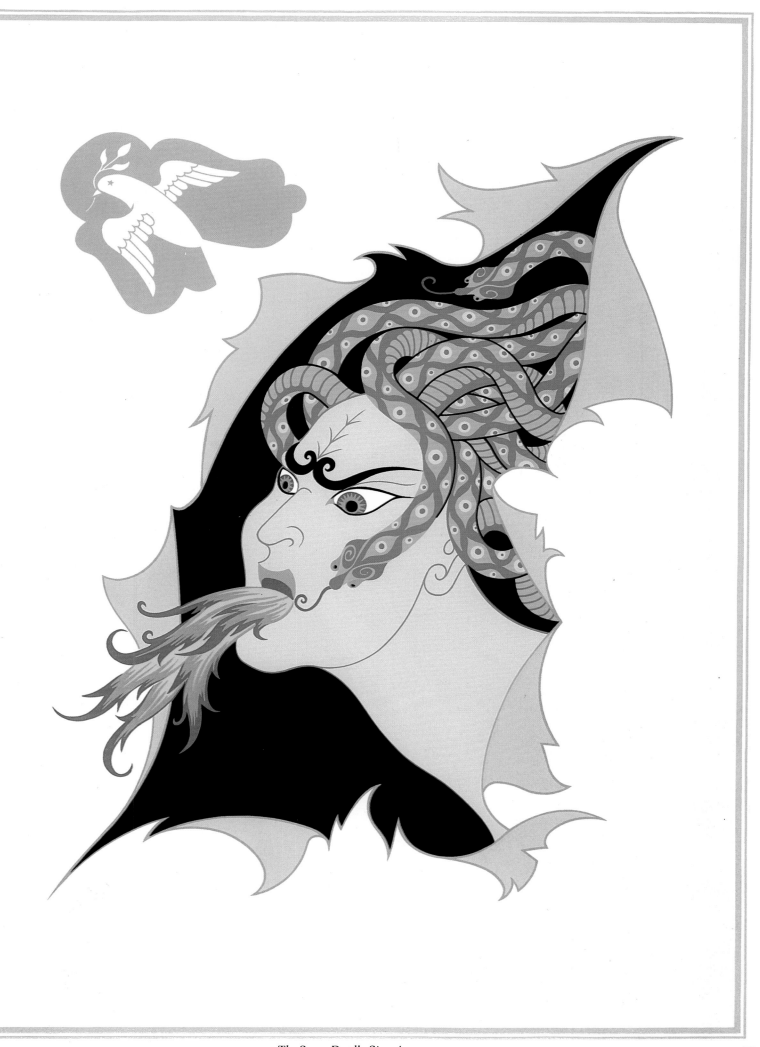

The Seven Deadly Sins: Anger

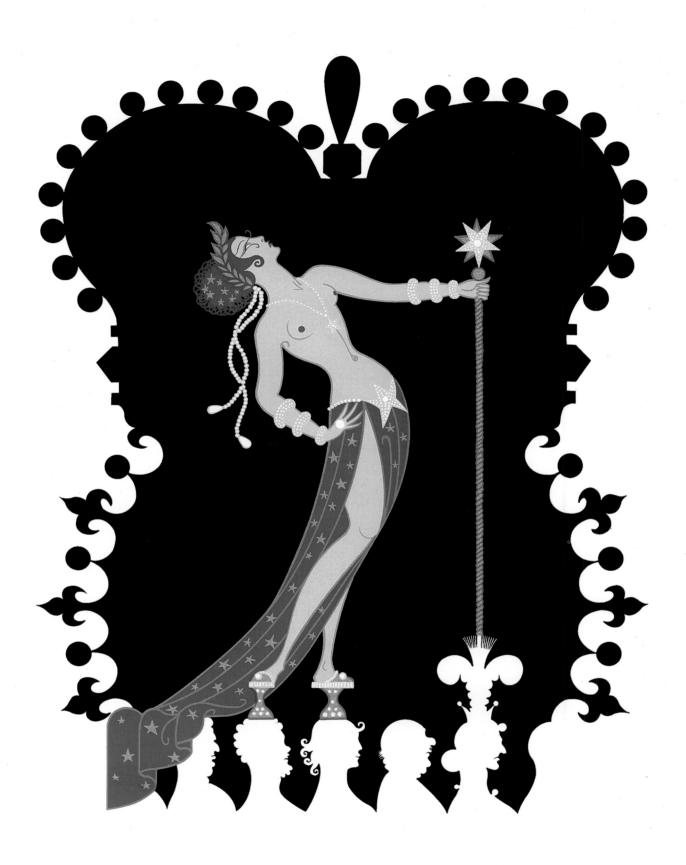

The Seven Deadly Sins: Pride

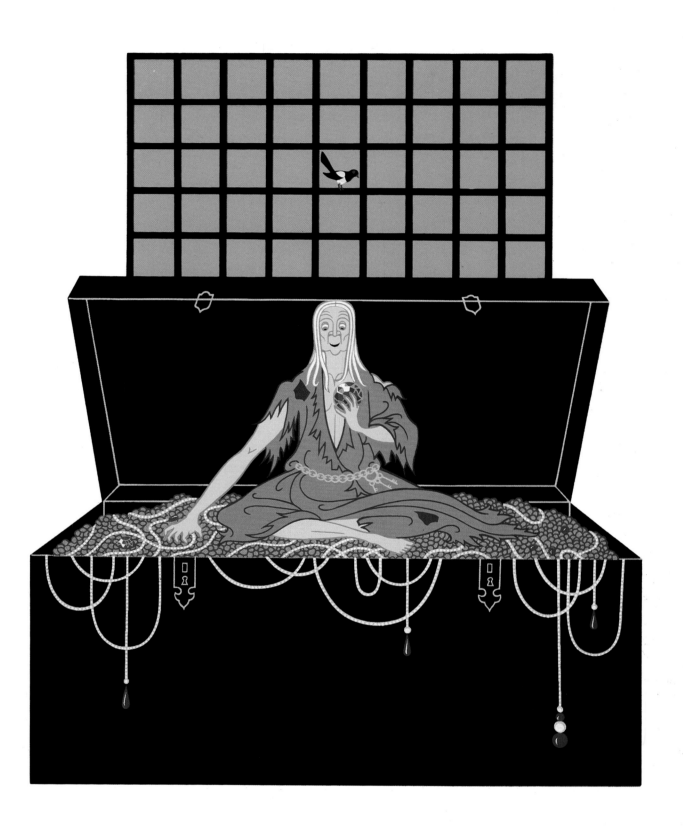

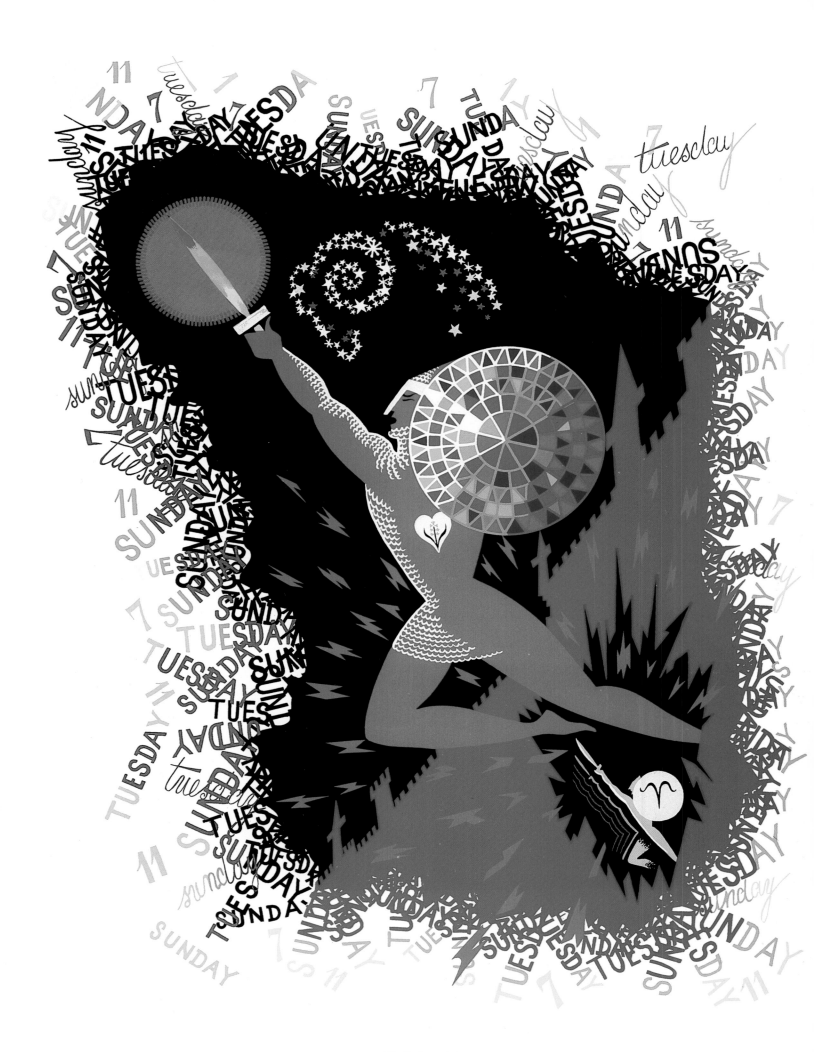

The Zodiac: Aries

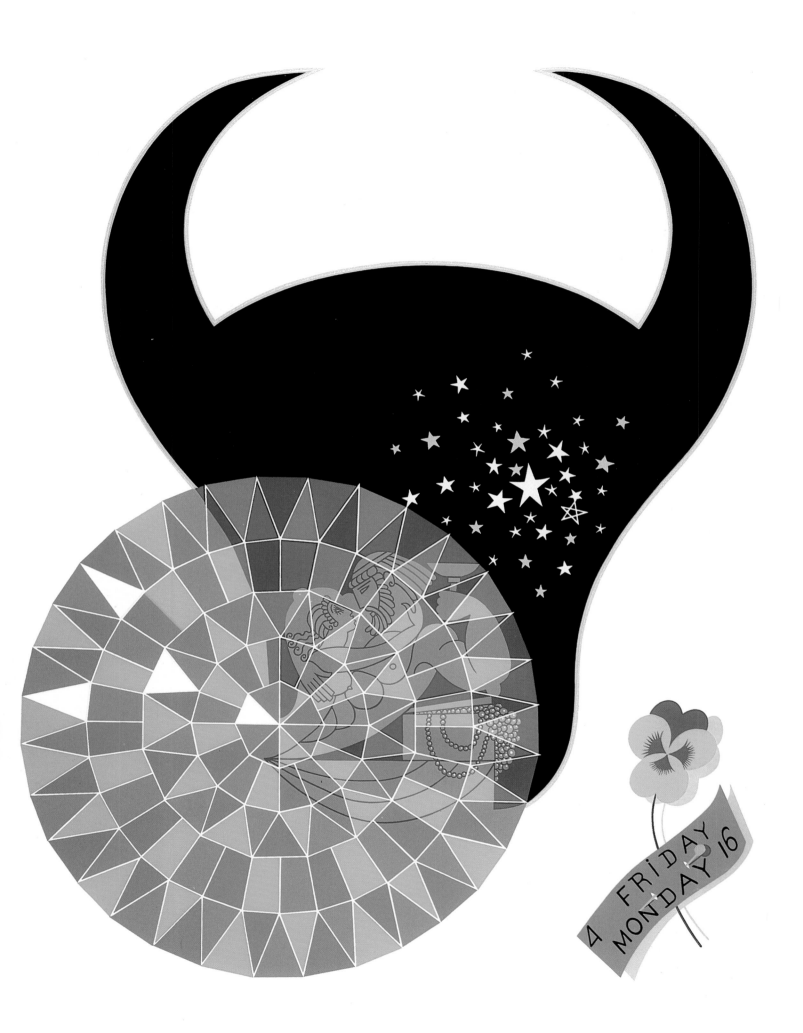

The Zodiac: Taurus

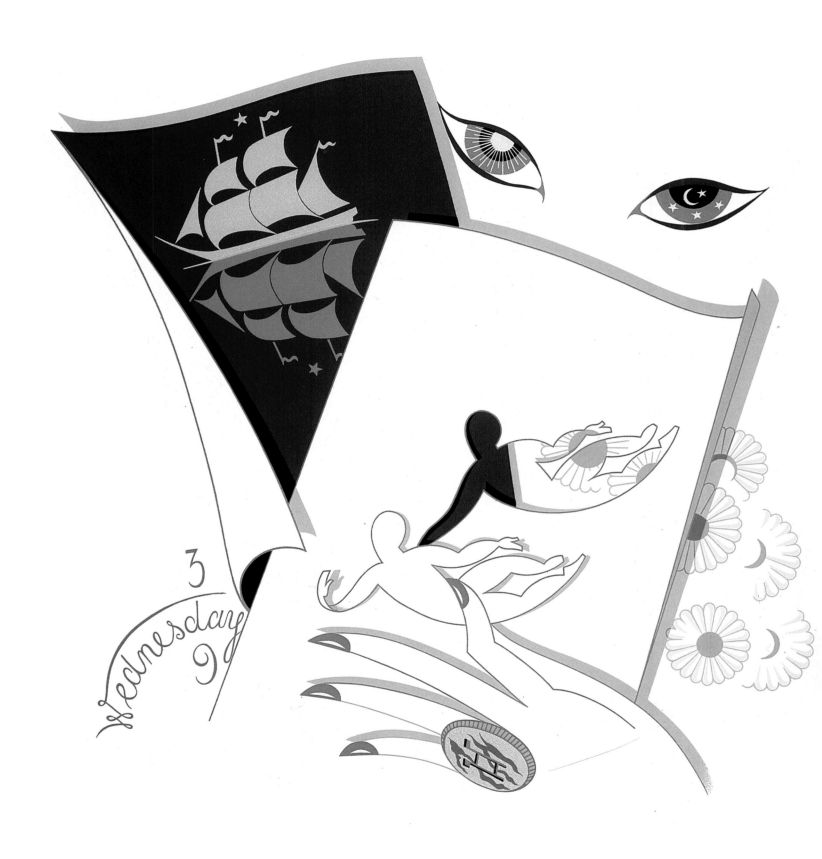

The Zodiac: Gemini

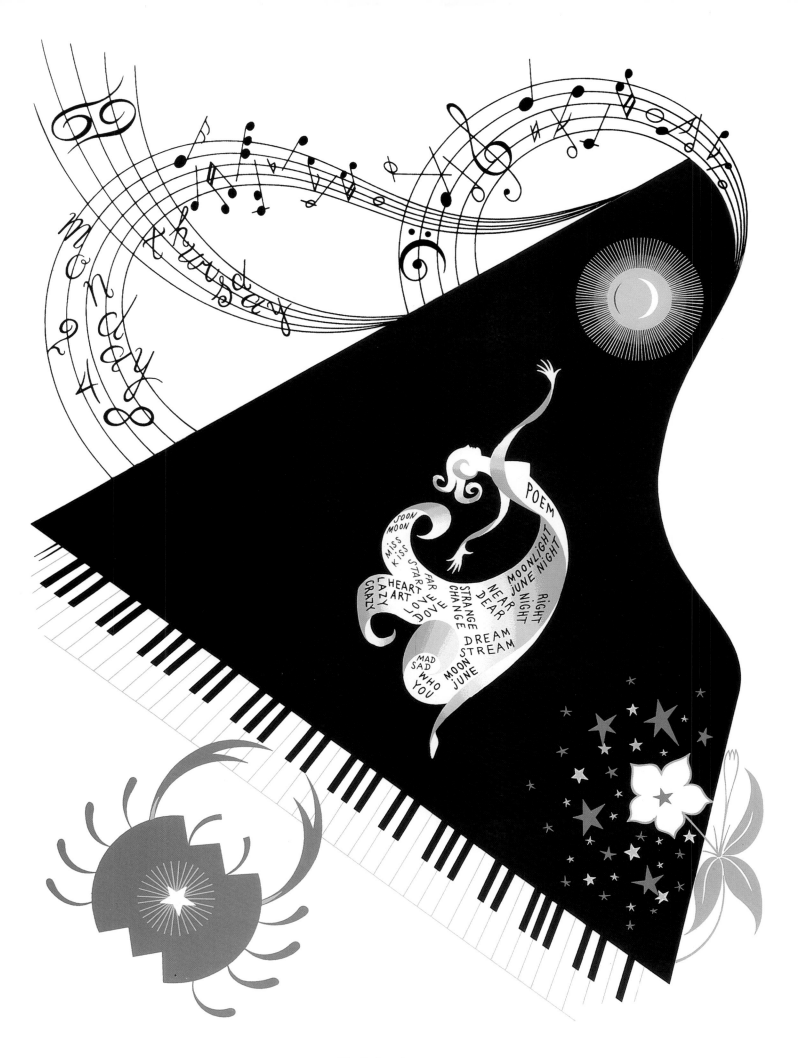

The Zodiac: Cancer

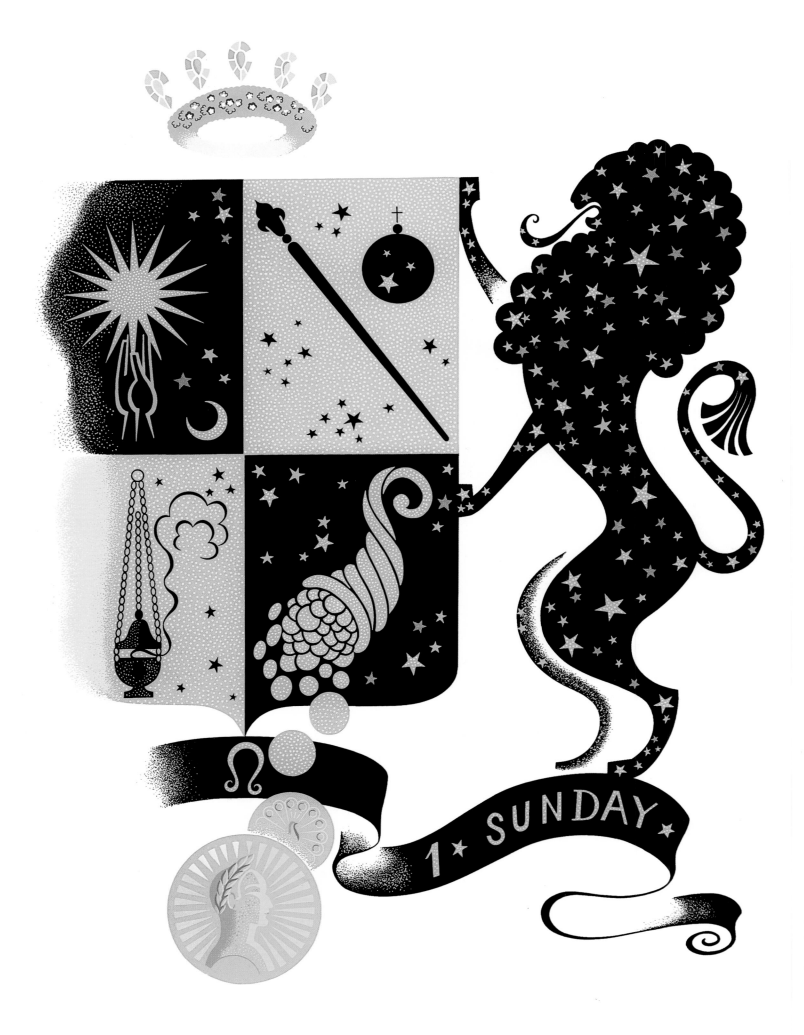

1 ★ SUNDAY

The Zodiac: Leo

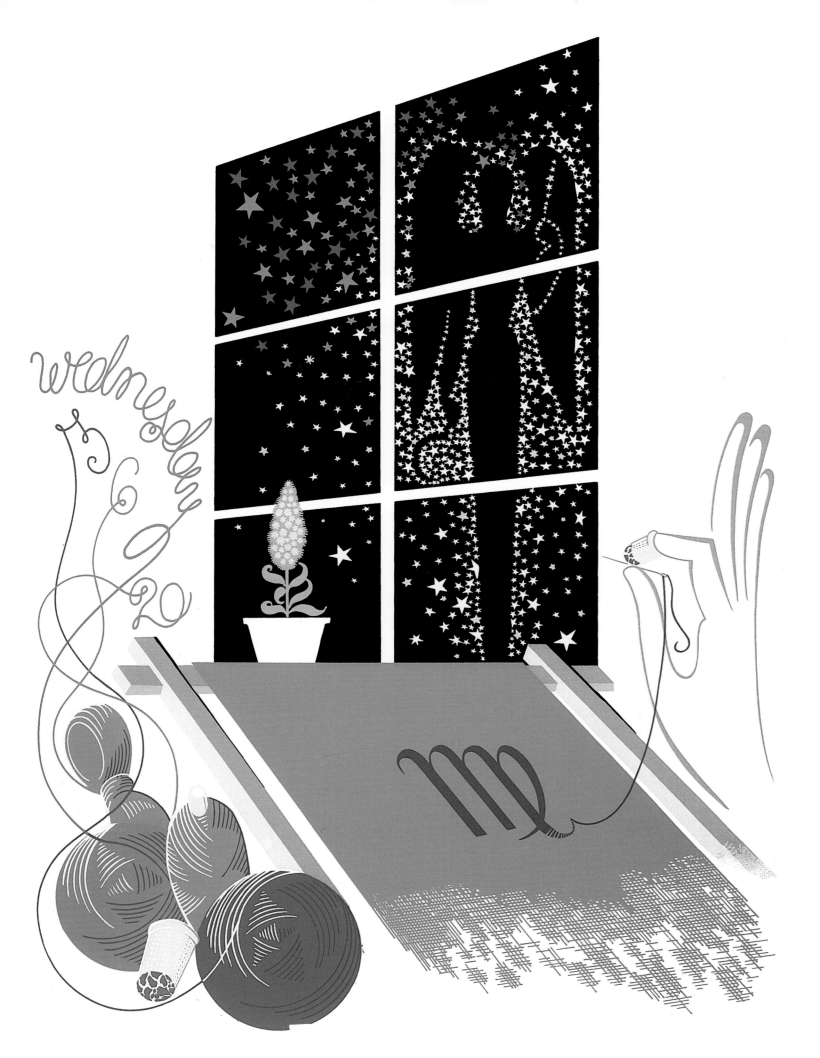

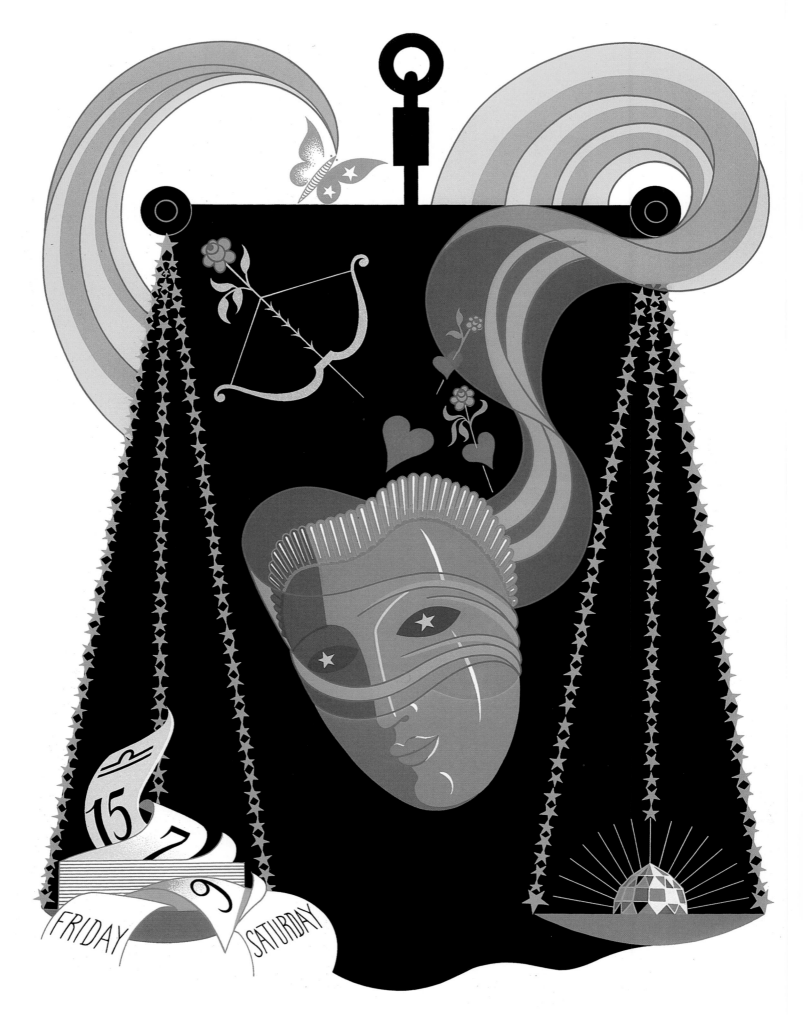

The Zodiac: Libra

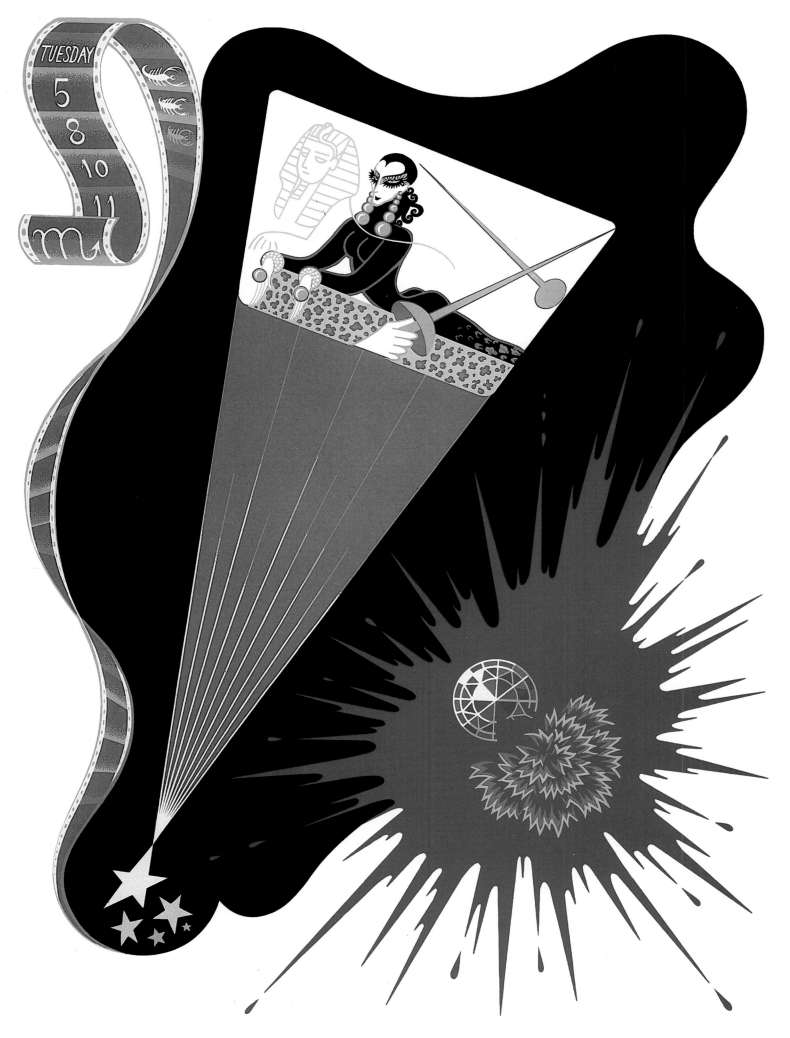

The Zodiac: Scorpio

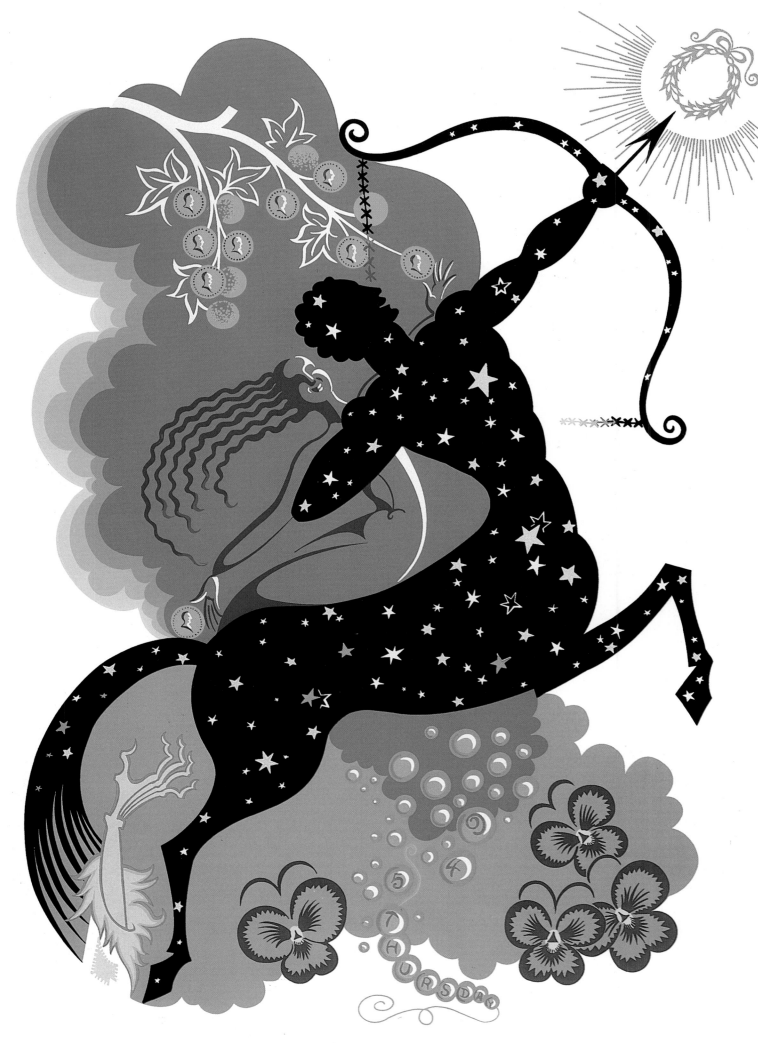

The Zodiac: Sagittarius